HUNGER FOR LIGHT

HUNGER FOR LIGHT

POEMS BY STEPHEN BROWNING
MONOTYPES BY KALANI ENGLES

FITHIAN PRESS
MCKINLEYVILLE, CALIFORNIA
MMVI

Published by Fithian Press
A division of Daniel & Daniel, Publishers, Inc.
Post Office Box 2790
McKinleyville, California 95519

Cover design by Eric Larson

Library of Congress Cataloging-in-Publication Data
Browning, Stephen, (date)
Hunger for light: poems / by Stephen Browning ;
monotypes by Kalani Engles.
p. cm.
ISBN 1-56474-461-2 (pbk.: alk. paper)
I. Engles, Kalani. II. Title.
PS3602.R74H86 2006
811'.6—dc22 2006009196

FOR CHARLES AND PATRICIA

CONTENTS

You must see for yourself
the white flowers in moonlight.

The Blue Cliff Record

These trees shall be my books.

As You Like It

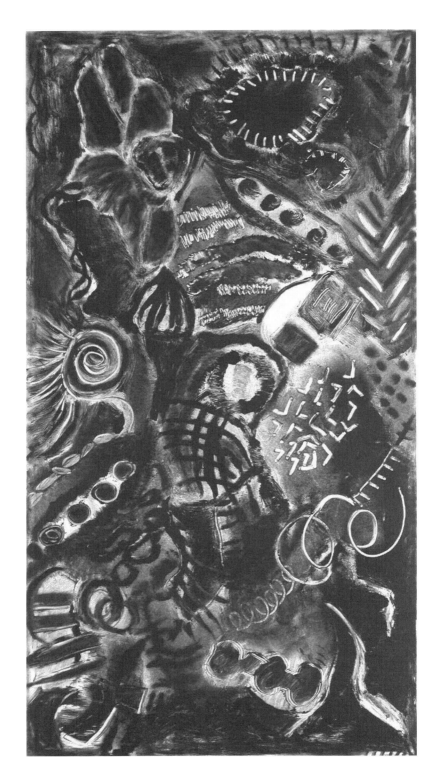

THE SCHEME

Maybe you are one of those gripped
by the compulsion of gardens, wading
knee-deep in a floral daze, lost in

plotting next season's beds, drawing up
a scheme of flowers in the mind.
And this fervor infects all you do,

whether dyeing white daisies
with violets, or countering the fuchsia's
languor with the springing iris,

sugaring the sour, the acerbic,
with pansy's sweetness, or grinding
the rose's thorn to a fine powder

to poultice the bleeding heart;
until there isn't a gardener
who wouldn't gladly trade recipes,

who wouldn't want to summon
the eagle down to the birdbath
or the eland to the spice beds,

braid mambas through the hedges,
and coax the armadillo into a scaly ball
to dance on the jet of the fountain.

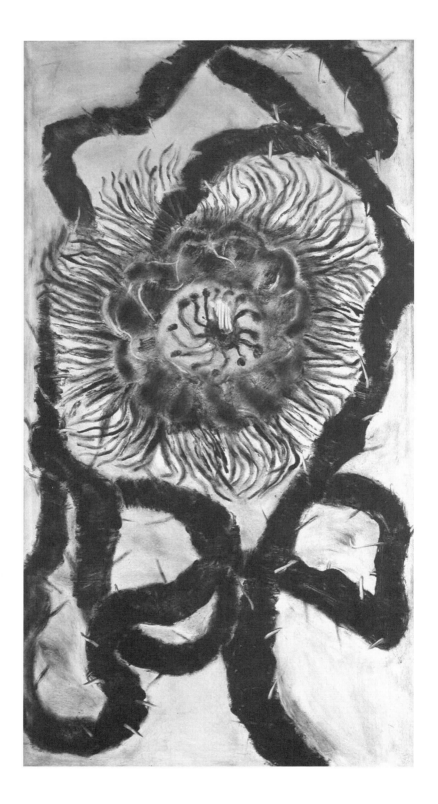

One really ought to consider
the parting of closely held petals,
the back-curl from the bud in
their spreading and preening,
the flex of their springing,
as the makings of passion.

One would do well to study
how alike are the waking yawn
and the unfolding blossom, its arms
stretched wide into the day,
and to notice particularly how
it offers itself to the world.

One could see, slowing oneself
a hundredfold, how enamored
are its held breath, its wild eyes,
its lungs aching for air, just before
the breakdown, the hiss of collapse,
the slow rush of letting go.

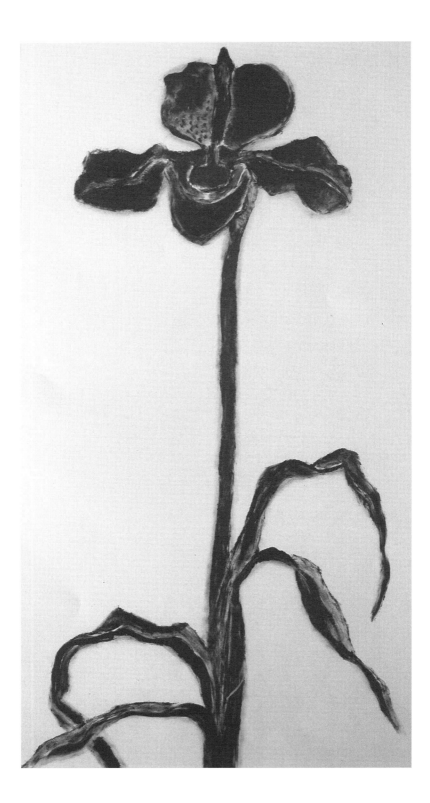

Can it be said to have a beginning
the way day has a beginning in its
separation from night, the way
a child has its beginning in birth?

The first orchid of the world is
like the first morning ray of light
to torch its way through a mountain gap:
the perfect channeling of a fire
that has blazed since the world began.

So if we can't say with any certainty
when some epiphyte gathered
enough genetic syllables
to be called *orchid*, or what deft insect
first triggered the soft latch
of its pollen, whereupon both
began to modify their essences
in light of the needs of the other,

we can, perhaps, say that it is
like all the mysteries of the world—
like love, for example, which grows
of itself, until it is suddenly declared,
and the life around it is changed.

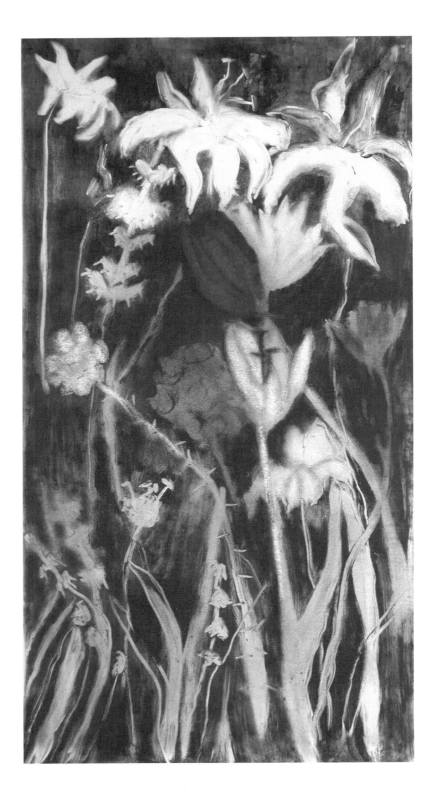

Coming upon a flower-crowded field—
rhizomes, corms, bulbs in their proliferation—
the force smoldering deep in the cells
that stretch or contract to turn each blossom's face
toward the light or rest in lunatic trance
under the soft glare of the moon,

you might ask how those cells harbor
this instinct for survival, the same urge that causes
the forest up on the hill to shift its ground in slow
cycles of waking, the trees on one side in
the despair of collapse, and seedlings
springing up like pioneers on the other.

And you might see such decision as a hunger
that is more than cellular, and which
with people would be called history,
but with flowers may simply inhere
in the mottled pattern
of sunlight among the stalks;

or the meadow vole at its succulent feasting
that finds itself, suddenly, under the wings
of a moon shadow; or the advent of winter ice.
Life in its multitude you might see as a steady
encroachment, a decay of structure,
like the scale of lichen spreading over rock, or as

the happiness of intention in the bones of a god
of whom might be said: *You were with me though I
was not with you,* because you might have thought,
oh, that is only a flower-god of little consequence,
whose ministry, like the skull of the vole
in the owl pellet, is hidden even from itself.

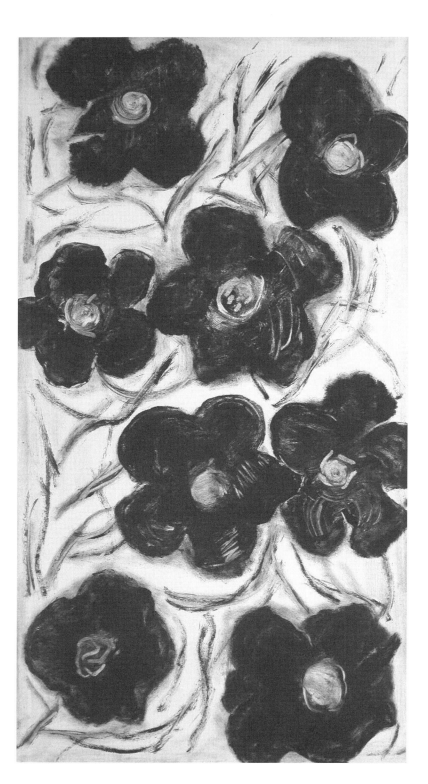

That these dimensionless black husks
adhering to their two-dimensional field
are actually three-dimensional flowers:

That, despite rational restrictions
which would prevent our choice,
we have asserted here a plot of ground:

That water, which would turn this field
to pulp, falls from the unseen clouds
and copiously wets the buried roots:

So that these flowers, depiction's benign lie,
pistils and stamens redolent with promise,
open to us in covenance and change.

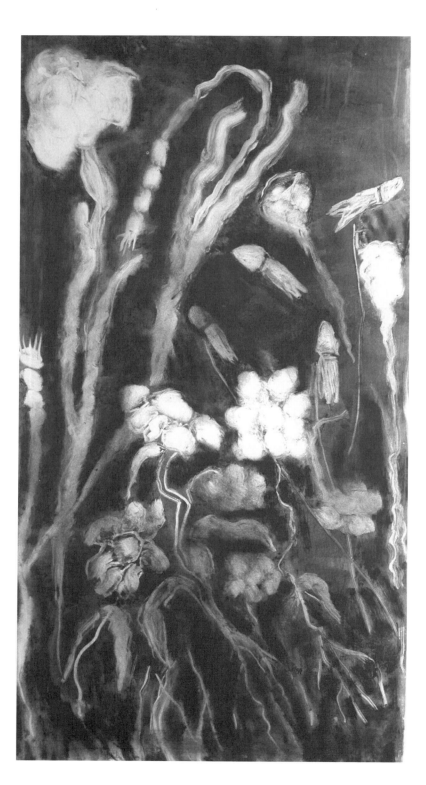

A square foot of grasses, weeds,
leaves, stems, seed heads, drawn
meticulously by Dürer around 1503.
And someone—I forget—once spent
a year studying a cubic foot of soil.*

I used to have a relative named Fern,
a girlfriend whose mother was Rose,
an acquaintance named Lily. In Greek,
I'm Laurel. Though it's not yet clear,
there's a hint of cousinship in which

we start to understand the depth
of the cube—to hear the laughter
in the grasses, see love's shadows
in the roots, and deeper, with its slow
changes, the richness of the dead.

* Likewise, if you were to observe closely
a cubic foot of air randomly chosen say ten
or fifteen feet above the earth, you might find
at some time every cubic inch of it penetrated

by bird, bug, leaf, or seed, lit up by fireflies
or darkened by the passing neck of a giraffe,
and see that it is part of the great thruway
circling the earth, in which creatures of all kinds

carve their paths, and that it is also potentially
penetrated by shadows of things passing above
which can only manifest against the solidity
of some surface and are thus invisible in air.

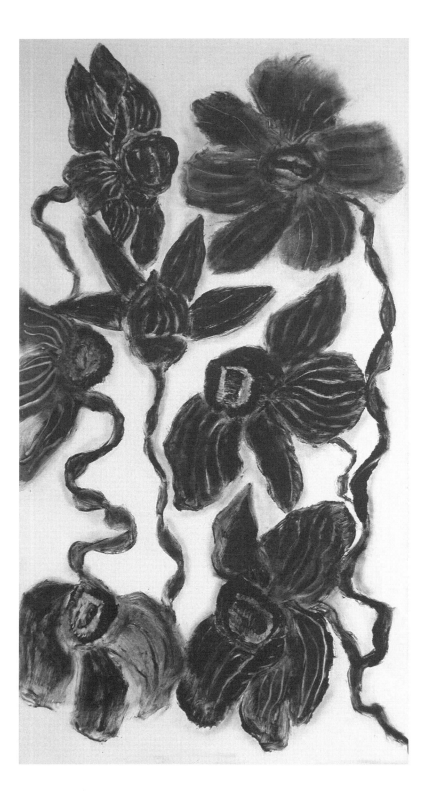

THE FORM OF LOSS

Have you noticed,
with patient eye,
the fall of each decomposing
blossom to the ground
where a pink carpet,
mottled increasingly
with delicate shades of tan,
is laid as its result?

Were you fortunate enough
to see, when their petals
had reached the extension
from which recovery
was impossible, how
their very form relaxed
into the soft compunction
of losses such as this?

And how loss, in its
recurrence, is the secret
in which life is contained,
the form of fulfillment
and change, and how
bud, blossom, and decay
are simply continuance
in necessity's disguise.

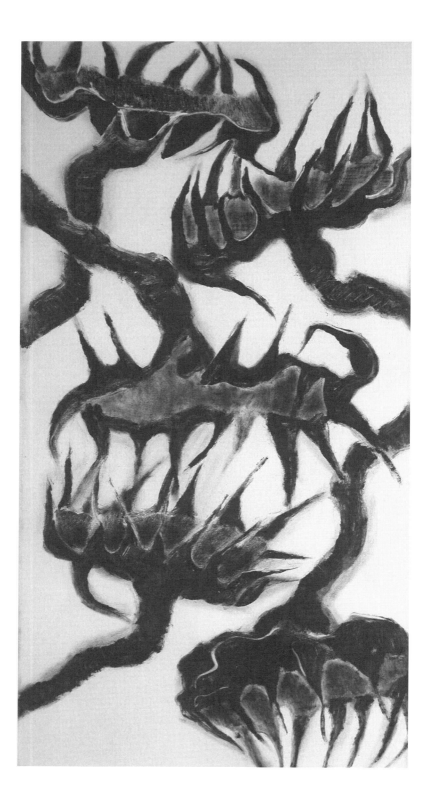

To name these blooms or
the season of their unfolding
is to name one's love
who waits in a darkened room

having come in from the sun,
in from the heat's loud drumming,
expressive contours shifting
in the unsteady light,

remembering something of which
you had no expectation,
like the stillness of drums that have
nothing further to ask.

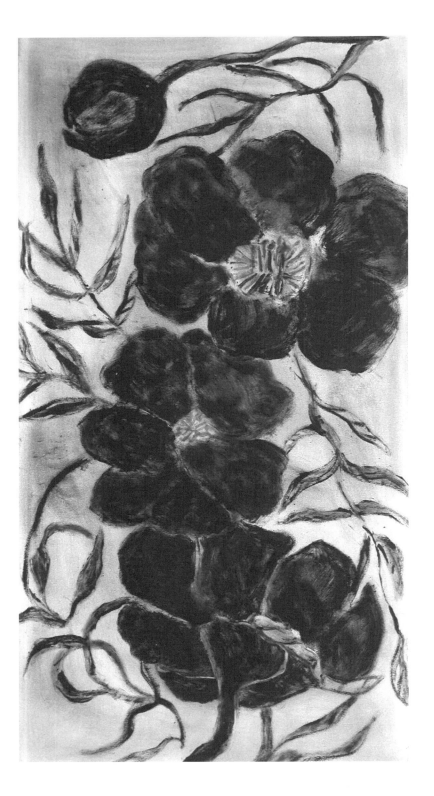

AND YET

And yet to see this flat ink
is not to see the flower
or is to see the flower
as it might have been

or still might be.
So does the doctor hold
the X-ray of some accident
up to an illuminated screen,

and see, more real
than what, obscured by flesh,
could only be arrived at by a guess,
that which the matrix of

the ordinary has kept hidden
deep in its core,
against interpretation
of the unopened eye.

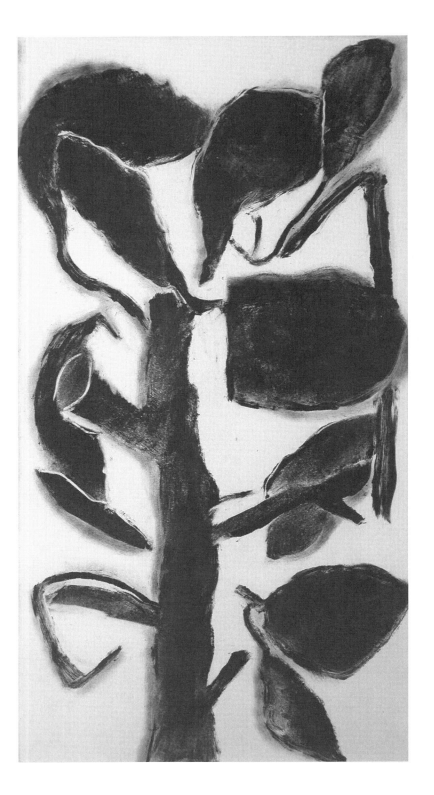

ELOQUENCE

Had the boot not crushed its green shoots,
nor aphids bled its veins, had not
the mole sheared its roots and drought
shrunk them in their earthen grooves,

had not caterpillars reefed its sails,
spiders tented its battlegrounds,
gibbons wrenched its fruit and
elephants ravaged its branches,

had not lightning riven its trunk,
the wreathmaker plucked out its eyes,
and the pruner thieved its spread,
the lightness of half such a loss

would uncrumple the green shoots,
rejoin the riven trunk, transfuse
the flattened veins, shore up the mauled
branches with buoyant struts of cloud,

and the earth would exult in its valleys,
the sun rejoice in a flare of tears,
and the moon extend its silver
crescent of welcome.

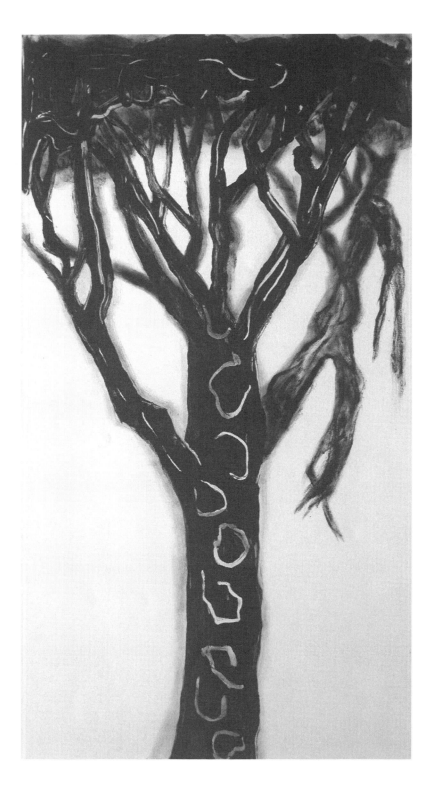

LUCK

Luck, that distinctive curl
of the leaves around the stem;

luck, the seed pod's rattle
in the abrading wind;

and luck, too, in the pattern
of forked, leaf-scarred twigs.

But then, what is luck but
the sudden rise of the flock

from the lake, winging and
wheeling, or the chord of

a fugue anticipating
the next in the mind of Bach,

or the rain of leaves from
the branch of an autumn tree?

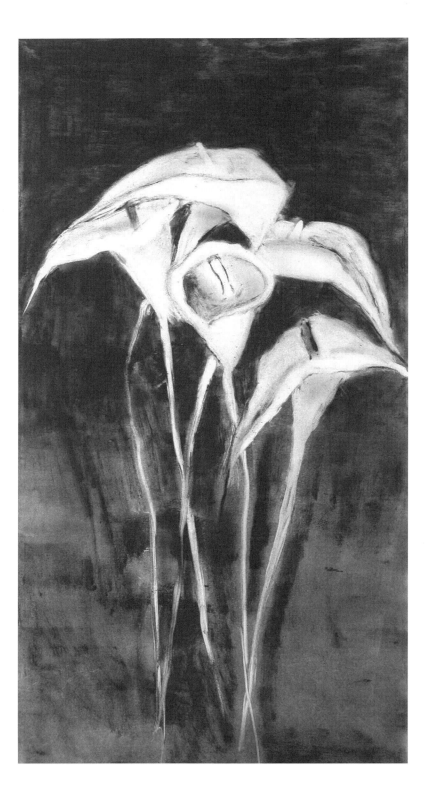

What are they up to behind that look of
butter-wouldn't-melt-in-my-mouth?

Might they be conspiring to secure the perfect angle
of the warm fall of sunlight on their invisible field,

or contesting with one another to be the first
to attract the first butterfly to squeeze from

its dark chrysalis under the first leaf
of a nearby tree? Or might they actually be

only a single lily preening in a triptychal mirror,
the depths of which will have caused her to reflect

on the advantages of multiplicity? We might think
such lilies are ambitious enough to undertake

every activity we can imagine, but we should remember
that we ourselves are making these suppositions,

that the lilies are only mental objects we have constructed
out of the suppositions we have entertained,

and that all these considerations are too great a weight,
really, for such suppositional lilies to bear.

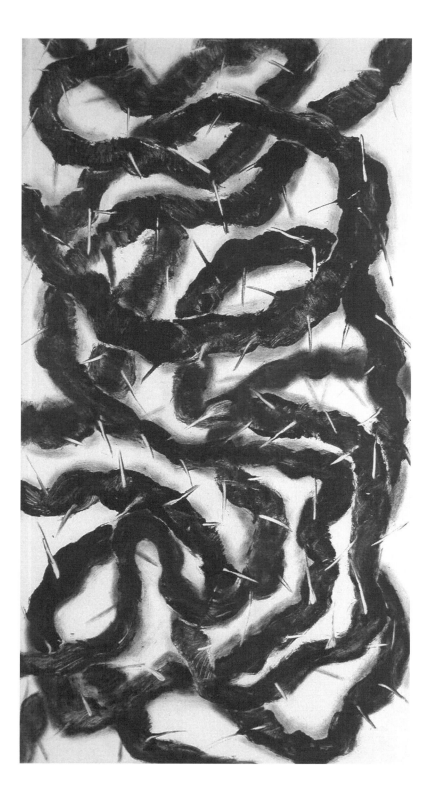

Consider how the thorned vine inheres
in the seed whose lucent capsule
inchoate in the flaring trumpet flower
is like a spindle wound with genesis,

a book begun, penned in a vibrant hand
but not yet published nor yet read,
a treatise on synecdoche, of parts
asserted boldly as the whole,

and in this volume, unfolding
its chapters as the vine roots down
and snakes out in its thick increase,
are pages telling of the *yet* of things

that casts, like a dark sun, no shadow
but the vine itself foretold within
the yet incipient seed: so does the hand
that shapes the vine take breath and sing.

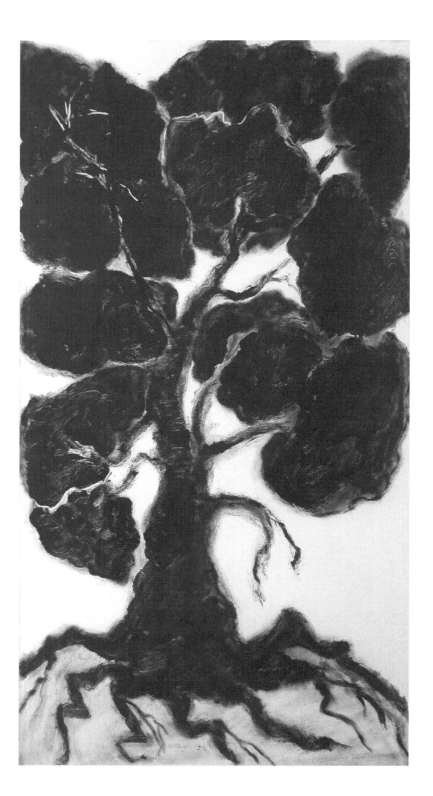

THE RECEIPT

From the night garden
you see, against window-
light, shifting cutouts
of leaves like clumps of lace
billowing in the wind.

It's then, among
these shadow trees,
the flail of dark bracts
silhouetted against
lambent clouds,

that a hand of air
slips you a receipt of wind
for this delivery
from the nursery
of the man in the moon.

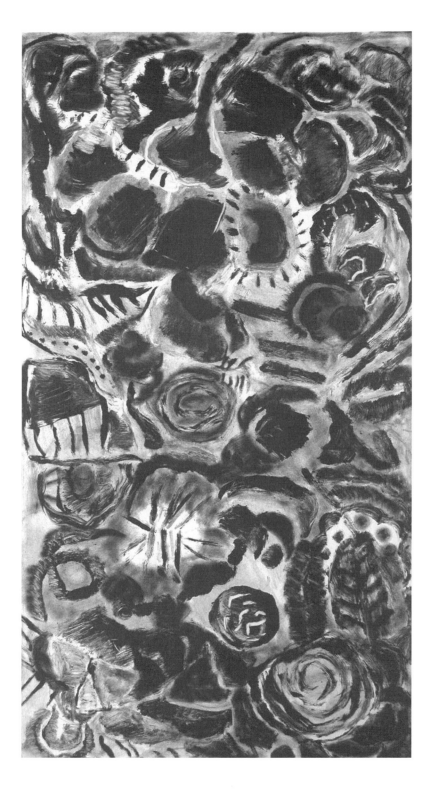

Flowers don't care what we think of them,
the flower mind being occupied
with particulars of season, water, light.

We know about the lilies of the field.
We may pretend that, like them, we don't care.
But we toil not at our peril.

What great people could we meet without
fear of judgment? To Shakespeare we'd be
minor characters, on and off in a brief scene.

We have escaped to the garden, where
the flowers care only for sustenance.
They are beautiful but shallow

except for the meaning we bring to them,
that within us forming that without.
By such means flowers become extraordinary,
invasive as weeds, whispering, Know thyself.

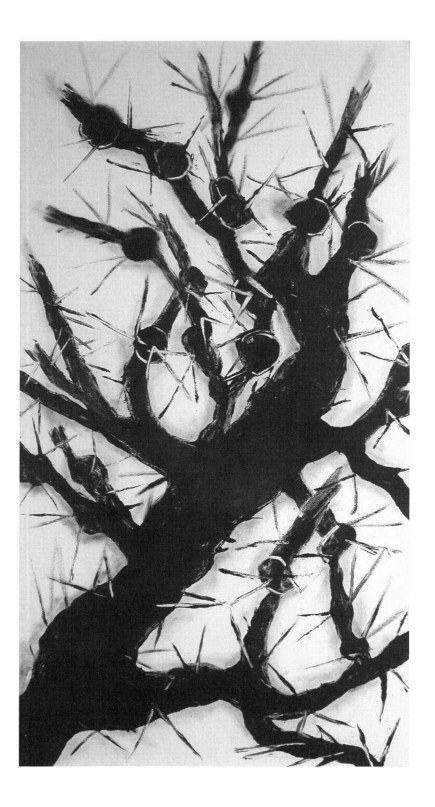

I've known the vegetative
smell of forests,
the taste of wood,
its bitter bark.

I've felt the pulse
of trees, slow as sloths,
the surrender of a branch
about to fall.

I have seen—
quick as thought!—
the moon through leaves,
how it spins and dances.

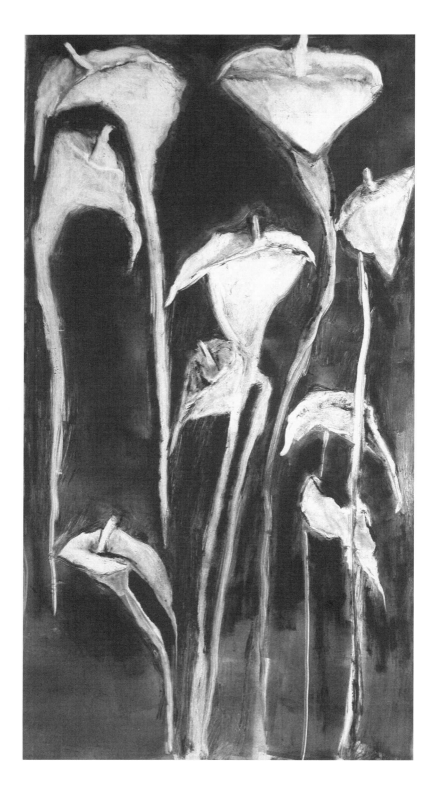

THE FLOWER ALTERS
IN THE ALTERED EYE

The vowels of the moon
are twin planets spinning around
and around their craters of air
and the tall consonants
of the lily are stalks whose roots

descend on the tail of the y
just as you yourself settle
in the expansion of your nature,
in a taxonomy meshed with
the universe of which you're part,

so that you become,
in your true interiority,
root, stalk, leaf, and flower
of the plant presently growing
in the forcing house of your mind.

Who can see a thing
without causing it to be
that-which-is-seen? What letters
can spell a flower without
metaphor, what taxonomy

unmesh it from the universe
that claims it? You yourself
are a creature of this system,
claimed, consonant and vowel,
as human, flower, moon.

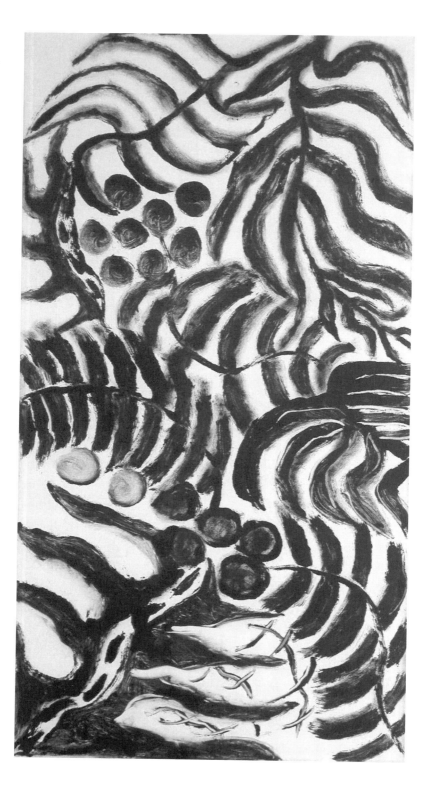

This is the sound of the thorn
as it pricks the air, the rub
of the root inserting itself
into its glove of earth;

this is the press of the leaf
on the night, on the slow
rise of the harvest moon,
on the evening star.

And this is the grip of the flower
on the hummingbird's breath,
on its long, driven tongue,
on its wings' blur.

It is held in the frozen hands
of the snow, felt in the wind's fold,
heard in the atoms
of darkness and light.

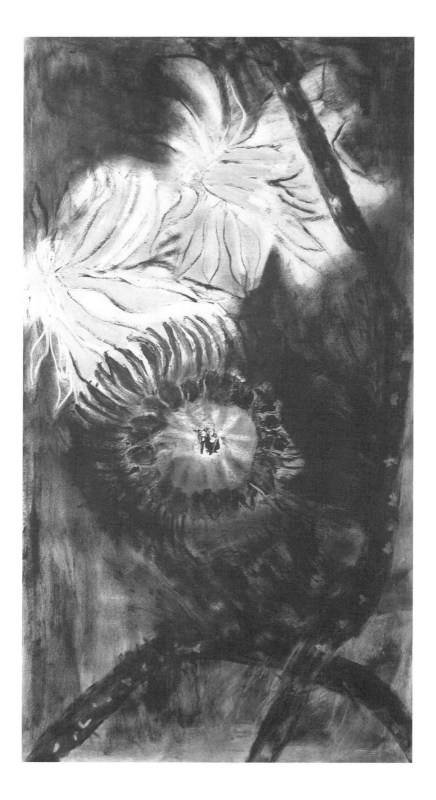

NIGHT BLOOMING

From rock to root
to stem, thorn,
culminating flower
drawing water
and earth into
a dense amalgam in
its floral vestments
of dark chance, the
gametic cycle of
a trap laid bare:
Who would censor
or be censured by
this brazen invitation?

Queen of the tropic night
whose court assigns
day-sleepers' revelries,
your thousand-stamened
chalice must collapse
and wilt at daylight
like a fairytale:
the coach turned pumpkin,
horses mice, your royal gown
limp and in tatters
on the thorny vine!

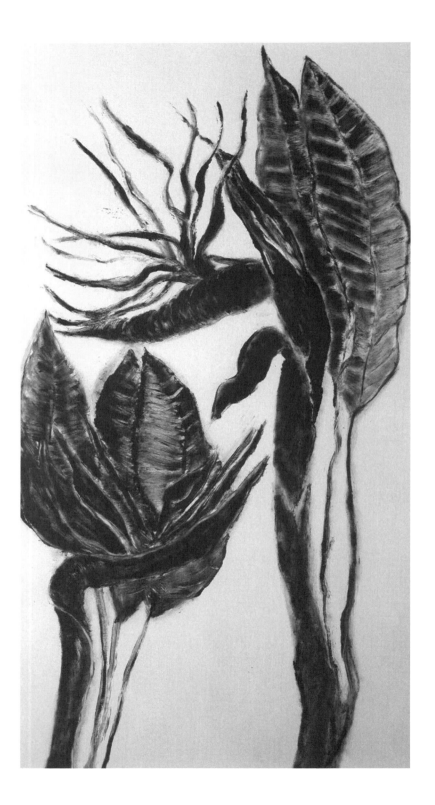

The pattern of flight that
trembles in the deer's hooves
and that which beats
in the hawk's wings
are not the flight plan
filed by this bird.

The deer springing upright,
the hawk plunging,
are not the gain of this blind growth.
And while this bird's bones are perhaps
more easily broken than those
of the hawk's wing that bear it

into the sky, they are as
unmoved as the span
of a steel bridge, light as the air
twenty miles up, and naked under
the moon's blue palette,
the yellow spectrum of the sun.

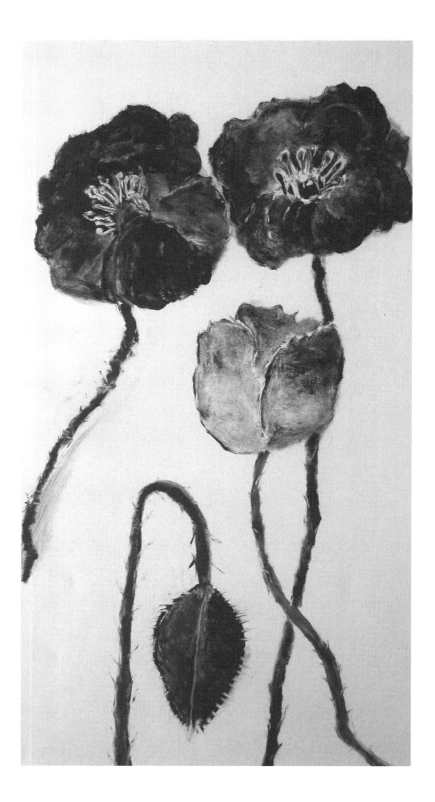

Poppies not seen since spring's
wet green fields faded
to summer's tawny pelt, before
July's cracked veneer preserved
the mud of hooves, tires, boots
in ankle-turning ruts,

its long days marked by
the sundial's shortened shadow
moving toward the crossroads
of the analemma's infinite glide,
the earth no longer overleapt
with wildflower firmament.

Not seen since spring, these brief
cousins of lethargy and dream,
whose regress in bright gold-
orange's sudden absence
has left mere poppy shadows
on time's lean field.

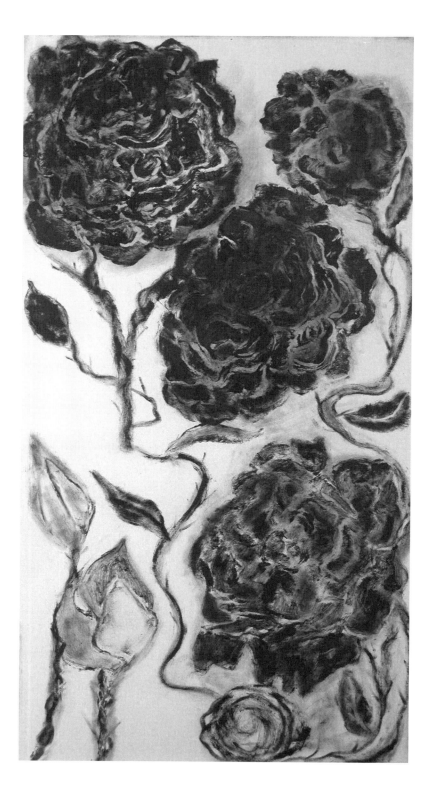

OH, GERTRUDE!

If a rose were a rose
and that only, then
no more than that
could be said about it.

Yet, even if this were so,
it would not stop anyone
from treating a rose
as more than a rose

if only by associations
gathered about it,
if only in the mind.
There are undeniable

characteristics of roses,
their perfumes, thorns,
the incredible fullness
of their unfolding.

Even *these* roses,
dark, static, silent,
partake of this
aura of richness.

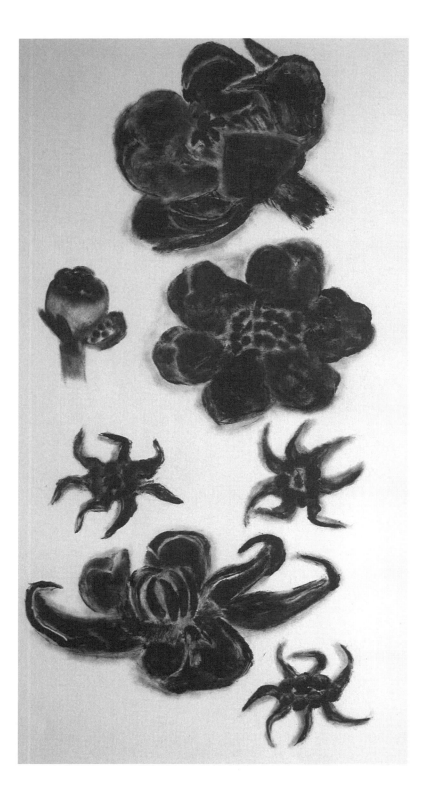

No longer precisely flowers,
their cells secured as carbon
by a lightning-lit field fire,
charred to stillness for some
ninety million years,
sixty times older than humankind,
holding perfectly the early shapes
of seedpod, pollen sac. . . .

New-found, new-named,
their mysteries now
classified away—I'd rather think
some of these small fossils
deep beyond the paleobotanist's pry,
tight in earth's subterranean hug,
corolla'd diamonds unseen,
beautiful and vanishingly rare.

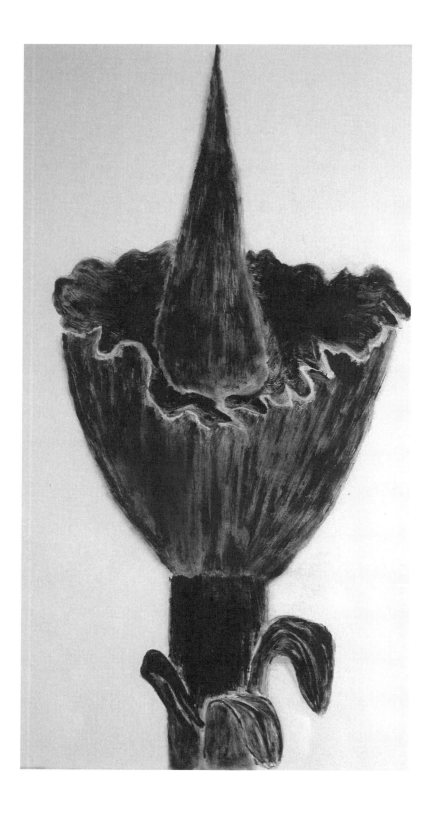

Maybe because both the great bell
from which its spike arises
and the five-foot spike itself
abstract the Titan arum from
the ordinary size of flowers
as the elephant is abstracted
from the general run of mice,

or perhaps because it blooms
so rarely, to most people
it's a botanical tall tale.
God knows humankind is also
alien to the rest of the natural world,
though in our case it's the reflexive
knowing-that-we-know, and

our facility in acts of choice.
So if I do not call attention to
this flower's horrid stench,
said to be like decomposing flesh,
it is by choice: for doubtless you and I
would smell as bad if long unbathed,
unpowdered, unperfumed.

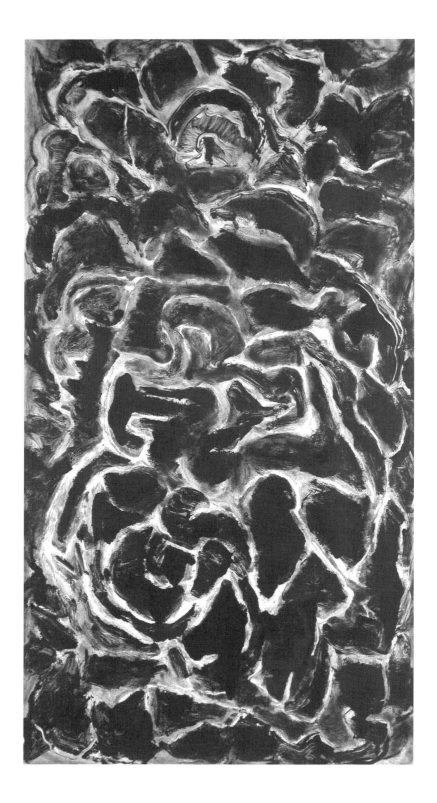

THE MAP

Like some leafy labyrinth
whose switchbacks, dead ends,
densities of purpose mark
each wren tunnel, beeline,
swift thruway, ant trail,
squirrel bridge: directing
all with stemmed gestures,
a plant alphabet, a trick
of chlorophyllous rhetoric—

O thick country of river roads,
we hear your whisper as
the slow creak of branches,
the snap of twigs in wind,
blind growth too slow for
eyes and ears to penetrate;
we walk unsteady through
this dark chart of our appetite
for meaning, this want of light.

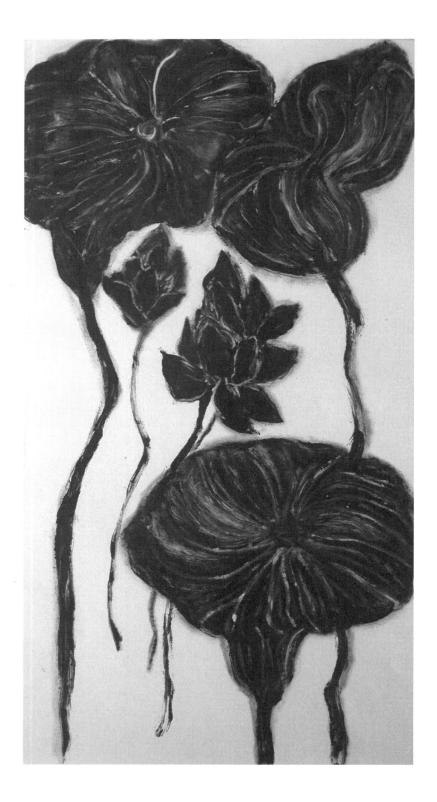

Your darkling dance, the flourish
of your shadowing forth, serve purposes
forgotten in the arrogance of my text
that makes the blithe, blind choices

hope involves. Which is to say,
for all my wild envisioning, I'm like
a white cane tapping, probing—not
your interpreter of choice, as I shake free

mind's glitter on your raven petals,
and chrome your roots like tailpipes. But if
it's simply light restores you, or water
taken indifferently from river, hand, or sky,

I must remember to remember mind,
casting perceptual dice, makes nothing,
changes nothing real. Nothing is added,
nothing taken away, and I am given

as collateral your blind, coiled seeds.
Who would be rash enough to force
my text's presumptions on your primacy,
to fix your innocent buds

on emerald stems, among translucent leaves
agile as clouds, shot with porphyry veins,
your bright roots dazzling outwards, and
ah! the moment at my sole command?

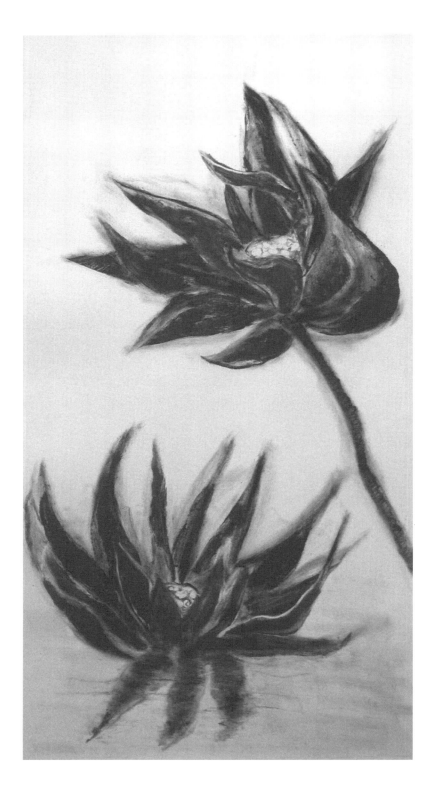

Maybe it was a lotus
lifting its head above the mud

set Coleridge wishing that
like Vishnu, dreamer of worlds,

he could float, asleep
on the infinite ocean,

cradled in a lotus flower,
and every few million years

wake for a moment
simply to reaffirm

he could go back to sleep
for a few million more.

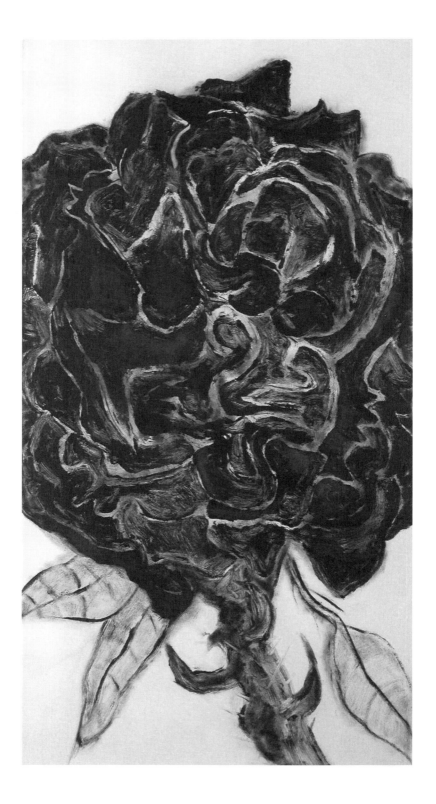

"What if you slept? And what if, in your sleep,
you dreamed? And what if, in your dream,
you went to heaven and plucked a strange
and beautiful flower? And what if, when
you awoke, you had the flower in your hand?
Ah, what then?"

 S.T. Coleridge

Then what? Ah, reverse,
O flower-dreamer, imagination's
track: You hold the flower,
or its image, then you sleep,

imagining a heaven where it grows,
for so are heavens made
and to such purposes as this.
In sleep then you descend,

leaving that strange, black flower
spread on heaven's vine-wracked vault
and wake to the smell of ink
and the page's rustle.

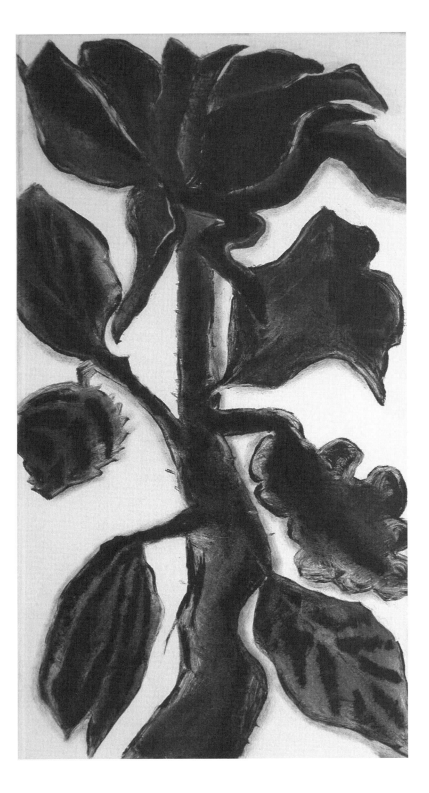

BLACK (DEGAS)

It was the painter
Edgar Degas who said,
"Never explain." And,
if pressed for details,
"Humph, he, ha." And
when he was seventy-two,
thinking back on his life
of paintings, drawings,
pastels, prints, wax
sculptures, of all those
dancers bathed with light
(who looked, in their tutus,
not unlike big flowers),
he said, so softly that
you almost didn't hear,
"If I could live my life
again, I should do nothing
but black and white."

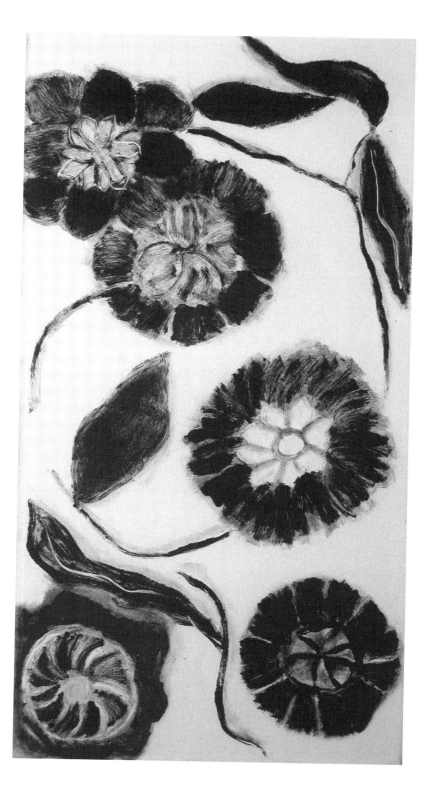

BLACK (CHRYSANTHEMUMS)

Nothing is as it was
to yesterday's eye,
whose expectancies
rest in agitation:

Nothing is as it is,
void's dish unstained
therefore unscoured, nothing
for the spoon to run away with:

Nothing is as it will be,
taking the world to task
with changes, for nothing
does not change:

Those black chrysanthemums
wrenched from some dark silk
onto paper like the shadow
of the moon on new snow.

PAGE 47 The blossom of the night-blooming cereus, with its profusion of yellow stamens, opens fully only in darkness and by morning has become a limp, drooping remnant.

PAGE 49 This is the bird of paradise flower, *Strelitzia reginae.*

PAGE 51 The California poppy appears during the spring rains in the foothills of California, but blossoms less frequently as summer's drought turns the hills the tawny color of a lion's pelt.

PAGE 55 Fossilized flowers about ninety million years old were found in New Jersey so perfectly carbonized and preserved that paleobotanists could precisely identify forerunner species and varieties of present-day flowers.